The Artist

by Alexandra Grant
images by Eve Wood

Project director: Alexandra Grant
Design and production by Jessica Fleischmann / still room
Edited by Florence Grant
Image scanning and separations by Echelon Color, Santa Monica, California
Printed by Conti Tipocolor, Florence, Italy
First edition of 1,300
Typeset in Argent CF and printed on Munken Lynx Rough

Library of Congress Cataloging-in-Publication Data is available on request.
ISBN 978-0-9988616-1-6

X Artists' Books
PO Box 3424
South Pasadena, CA 91031
USA
www.xartistsbooks.com

For █.

From the Secret Files of the State

**Redacted for public viewing
on January 16,** ███

Commander: Your name?

Warden. ▇▇▇▇▇▇▇▇.

Commander: Your title?

Warden: Senior Warden, Prison ▇▇▇▇▇▇▇▇, known as the Artists' Prison.

Commander: How many years have you been Warden of the Artists' Prison?

Warden: Thirty-four years.

Commander: Do you know why you are here?

Warden: Yes, sir, to give my evaluation of the prisoners, so that they may be transferred when the prison is closed.

Commander: Prison ▇▇▇▇▇▇▇ will close in May.... Why is it called the Artists' Prison?

Warden: Because of the punishments.

Commander: Are all the prisoners artists?

Warden: No, not all of them. Not when they arrive.

Commander: But when they leave?

Warden: It depends.... (*adjusts the microphone*) But, sir, very few of them have ever left.

Commander: That's what we are here to discuss. You prepared a report on each prisoner?

Warden: Yes.

Commander: Then let's begin.

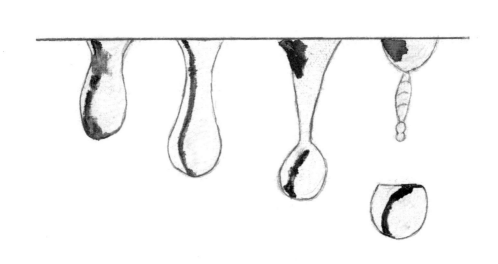

Prisoner #1: ██████████████ , the Water Artist

Warden: Every morning after breakfast, Prisoner #1 is led back from the dining hall to his cell. He is searched. If he hasn't taken anything from the dining hall, he is escorted to the lavatory, where he completes all discharges. During this time his cell is searched for any materials that might be ground into pigment.

Commander: Can you please explain?

Warden: ██████████ 's time at ████████████ precedes my own. He wasn't incarcerated because he was a thief, but in my experience, he is a very adept one, finding any material that can be transformed into paint, ranging from his own excrement to toast. As a result, everything in his cell is white: his clothes, his sheets, the paint on the walls. And for the same reason he no longer has a sink or toilet in his cell.

Commander: Please continue.

Warden: After the prisoner is reintroduced to his cell, he is given a bucket of water and a single paintbrush, about five millimeters in diameter. The wall across from his bed has been specially covered in a thick cotton drawing paper, which runs the length of the room, about three meters wide. The paper is a meter and a half tall.

████████ paints for two hours before lunch. He works feverishly, covering up the paper in broad gestures. Despite his age, ████████ is in good physical condition, and so he moves back and forth as though he were dancing. Sometimes the guards, who check on him through the small window every fifteen minutes, observe him standing back and contemplating his work. To the guards it looks like ████████ is staring at a blank wall. They see nothing at all.

At lunchtime, Prisoner #1 is walked back to the dining hall, and after the meal, the process is repeated. He's searched, taken to the lavatory, then returned to his cell. He immediately begins painting again until dinnertime.

During dinner, the paintbrush and bucket are removed from his cell until the next morning.

██████████ paints for two hours between breakfast and lunch, and for four hours between lunch and dinner. Every day he completes a work of art, and every night it evaporates. Only he can see his compositions. After dinner, thoroughly exhausted by the day's work, he sits on the edge of his bed and again contemplates the paper on the wall until he goes to sleep.

We change the paper every four or five months, depending on the wear and tear.

Commander: What are your recommendations in his case?

Warden: I strongly recommend that Prisoner #1 continue to be held where he has no contact with any material that could become pigment. When he was able to paint images the rest of us could see, the imagery was so horrific that it caused the guards who discovered it to faint, apply for furloughs, or gradually lose their own sense of self. His pictures are so specific, so wormlike in their ability to obsess the imaginations of those who encounter them, that he is thought to be as considerable a danger now as he was when he was first incarcerated. Over forty years here at ██████████ and the ferocity of the symbolism he paints is undiminished.

Commander: There is no way to change his imagery?

Warden: No, everything was tried before he was interned at ██████████. And in my thirty-four years his content has remained consistent. It is my opinion that water painting is the most humane of punishments in this case, as it lets him freely express what is inside him without greater harm to himself or others.

Commander: Doesn't it strike you as sad that every night the fruits of his labor ... disappear?

Warden: Commander, as you know, my own feelings are not part of this assessment. Water painting is a punishment appropriate to his creativity, which is in itself his singular crime. I have no pity for him as either an artist or a human. We have sought to care for him without giving him the opportunity to expand his audience beyond the one he has in himself. There are certain artists, as in this case, whose work should never be seen.

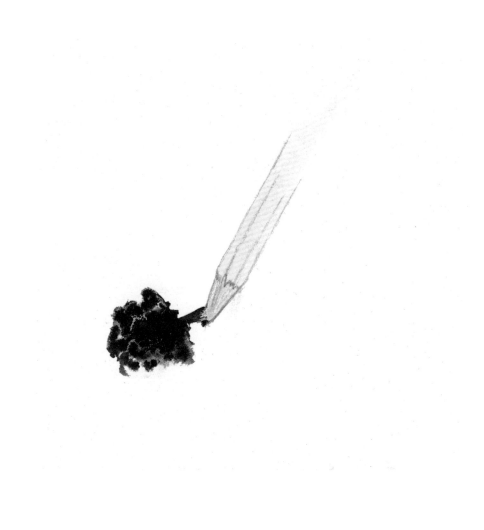

Prisoner #2: ███████████, **the Blind Draughtsman**

Warden: Prisoner #2 is the second-oldest prisoner at ███████████, and he also antecedes my appointment as Warden. His story is much like Prisoner #1's in that he created images that were so corrosive to our laws and standards they were deemed banishable offences by the State. As you can see in the entrance formulae, as well as current medical evaluations, we concluded that ███████████ destroyed his own eyesight with his drawings. The State's original sentence was to keep him here in prison, and, like the Water Painter, provide him with paper and a brush with no ink but water. But we made light of the problem because of his blindness. It is not that ███████████ is very clever or that he outsmarted us. I think the forces at work in his own imagination are more toxic than even he can comprehend, for who would destroy their own sense of sight?

Commander: He was blind when he arrived at ███████████?

Warden: Yes. That's why we miscalculated. After his initial incarceration we let ███████████ make drawings with water, at a small desk in his cell. We never told him that he was painting with water instead of ink. At the end of each day, we threw away the blank sheets of paper. What we didn't know is that forces acting against the State were looking through the prison's refuse. What we thought were empty sheets of paper were in fact engravings of the most noxious force, demonic images carved into the paper using the hard tip of the brush handle as a tool. ███████████'s images were widely distributed because the inkless drawings could be used as a form of plate to make prints. I think you'll recall the Second Blindness of 19██?

Commander: Yes.

Warden: What was little known about it was that it was also a biological reaction to ███████████'s drawings, like the First Blindness. Luckily for the State, the people printing and distributing the drawings didn't know their bleak power, so many of the forces conspiring against us were struck with the blindness themselves. Prisoner #2 was shocked by the outcome when we told him. We are certain he knew nothing of the distribution of his work outside the prison. When he was resentenced, he suggested his own punishment.

Commander: Which was?

Warden: That he be allowed to tell his story. If you go to page ███ of the dossier then you can see that the Blind Draughtsman is forbidden from drawing. There are no pens or sharp tools allowed in his cell. What we have permitted instead is a voice recorder. ████████ has an incessant need to express himself. The need, as evaluated by the medical team, is onanistic.

Commander: Onanistic?

Warden: Masturbatory, self-involved. Every day, we introduce a voice recorder to his cell. There is no strict pattern as to when he speaks. He sits quietly on his bed, thinking. When he was drawing, his hands were out of control. When he is focused on a story inside his head, he keeps his hands neatly folded in his lap or on the desk. And then he pushes "record." The voice recorder only has one button. Push it once and it records. Push it again and it stops.

Commander: And what happens to these recordings?

Warden: I'll explain in a moment. But to conclude the record on Prisoner #2, I'd like to recommend that ████████, the Blind Draughtsman, should not be allowed to return to society without strict controls on his creative output. ████████ is as big a threat to himself and the world outside as he was when he was convicted of causing the First Blindness. We underestimated his powers here once, which led to the Second Blindness. Any contact with drawing again could lead to another epidemic, and now thanks to changing technologies and ease of distribution, the epidemic might be more widespread or could be used as a political tool. ████████ is not a malevolent creature, but his drive to expression is stronger than his own understanding of the consequences of his creativity. Or ours, for that matter. Therefore, I recommend that he be kept away from any technology for the dissemination of his thoughts other than the voice recorder. And the only way this can be guaranteed is that he be kept imprisoned.

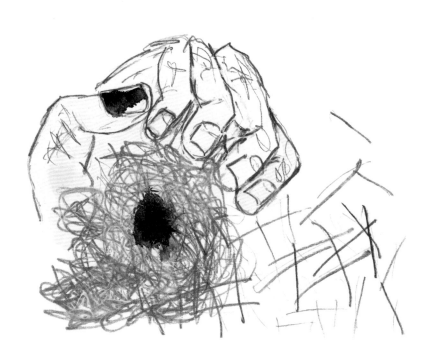

Prisoner #3: ███████████, the Narcissist

Warden: As part of her punishment, the crimes of Prisoner #3 will never be discussed. The mere mention of her ~~crimes~~ only serves to proliferate ~~them. Such are~~ the disproportionate ego problems of Prisoner #3, the Narcissist, that the State doesn't want to be the distribution mechanism of her megalomania.

The State's prescribed punishment, as you can see from the documentation in front of you, sir, was to sentence ███████████ to a lifetime of listening in order to encourage an empathic response. Of course the form of this punishment, in practice, took many attempts to get right. As an egomaniac, ███████████ would not just listen to anybody or anything over the long term. As it happened, when we were resentencing ███████████, Prisoner #2, we had a synchronistic idea, an experiment really, and have as a result linked, in what has proven to be more than a temporary way, the fates of these two prisoners.

It is Prisoner #3's duty to listen to and transcribe the recordings of Prisoner #2, the Blind Draughtsman. Prisoner #3 has a live connection to and a temporary archive of everything that Prisoner #2 recounts to the voice recorder. After breakfast and lunch, she is escorted to the library, where a special desk has been set up for her. It is for her use only, which gratifies her boundless need for recognition and special treatment. The desk is our way of controlling her behavior. In fact, she is probably our best-comported prisoner for the simple reason that any errancy will lead, soon enough, to her being denied access to her desk.

Commander (*reading*): It says here that she refers to her desk as the "switchboard."

Warden: Yes, she does. But neither I nor the prison staff ever refer to it as such. We always call it the desk or ███████████'s desk.

Over the course of her incarceration, ███████████ has transcribed 27,832 hours of Prisoner #2's stories. Unbeknownst to her, the man who takes the pages from her actually works as a publishing agent for the State. As a result of her work, twenty-six Blind Draughtsman novels have been printed. Twenty-four of those have been best sellers, with twelve million copies in print, and translated into twenty-seven languages.

After the publication of the first Blind Draughtsman novel, ███████████████, the State authorities were concerned with the increased ego-satisfaction of the prisoner now that she'd become the amanuensis for a published author. But as you know, the publishing house is owned by the State. The novels are a huge revenue stream for the prison. And the publication of the novels led to our increased ability to regulate and control ████████'s behavior. Her narcissism is in fact her greatest weakness and the source of her own self-betrayal.

Neither the Narcissist nor the Blind Draughtsman knows the identity of the other. This was ascertained a few years ago, when the prison reading group read one of the novels. The Narcissist listened with a barely concealed grin, congratulating herself as the "writer" of the stories. The Blind Draughtsman listened without a hint of recognition. But the tapes and the text are very close in content.

We have created a closely controlled economy regulating the input and output of the Narcissist. We could easily release her to the world when the prison is closed. But what would the consequences be? No one would believe her if she said she was the ghostwriter of the books, as they've been published under a man's name. As you know, the publishing of books is a State secret. And, now, she's totally dependent on the State for the content and dissemination of her creative output.

As you can see, in her recent letter, #█████, ████████████ has written me directly for permission to remain imprisoned. So it is my recommendation that both Prisoner #2 and Prisoner #3 be transferred, in tandem, to another prison. And though this should not cloud our judgment in this matter, we cannot undervalue the future profits guaranteed by this arrangement and their benefit to the State.

Commander: Why do you think that the Blind Draughtsman's drawings have a lethal power, but his stories don't have the same effect?

Warden: There is a cliché that persists from the former state, "A picture is worth a thousand words." Each of his stories has only a fraction of the potency of his images. And because words are so slippery, each having more potential meanings or interpretations than the last, they are a less virulent medium for the Blind Draughtsman's poison. I saw a drawing of his once, wearing the Blindness Glasses, of course. Even with the glasses on,

I could see that the drawings left nothing in doubt. My eyes began to burn at the corners, and a scorching sensation began to envelop one side of my face. I had to turn away. There was no possibility of interpretation.

Take a bath. Eat a donut. Scream at a goat. Go to the bathroom. Stand on the platform. Farm out your sperm. a Sk your [...] questions. Murder a sparrow. Cough on a squirrel. Teleprompt your mother. Excommunicate your husband. Disband your Pizza Club. Pick up the Kids. Drop Them off Again. Borrow a [...] give back the hammer. Sell off your [...]. Call home the [...]. [...] your breast milk. Salvage the Lakehouse. Pick up the rat turds. Do stay a person. Melt [...] candles. Vomit up the [...]. Kill a Sar[...] the bathwater. eat a good [...]. Try to [...] sutary. Enga[...] Raise the [...] eczema. [...] the the [...] [...] Cellar [...] lick the spurs. Attic [...] down Darke[...] [...] In the ga the kitchen. Marry the mer[...] [...] rden. Chase the black car. Scramble the sacred **EGG**. Break an [...] [...] head. Converge into Nothingness. Poop on the [...] hole. Engage the enemy. Sleep with your [...] [...]fully. Fix the electric heater. Frolic in the ga[...] [...] your intestines. Convulse Insi[...] your breath. put [...] your sandals. take up the cause. splinter the wo[...]

Prisoner #4: ███████████, **the Instruction Artist**

Warden: I've never seen Prisoner #4. ███████████ is confined to his cell an arrangement that was made in 19██ before I came to ███████████. Every morning along with his breakfast tray, he is passed a single sheet of paper. At noon the breakfast tray is collected and his lunch tray is delivered. At 5 p.m. his lunch tray is collected, and his dinner tray is delivered. At 7 p.m. his dinner tray is collected, as well as the single piece of paper. From his file I've learned that this arrangement is far preferable to when he was allowed into the dining room and used furtive methods to make his documents, these "instruction sets" that he circulated among the prisoners, hoping to get them to the world outside. The former Warden realized that it was better to quarantine ███████████, as it were, and assume a direct role in the creation of his work.

This routine happens every day of the week except for Wednesdays, when his room is inspected and cleaned, and he's kept in a holding cell temporarily. Some days, it's true, he returns the piece of paper blank. We've learned to return the paper to him the next day. Some days he sends out a series of instructions that seem not quite finished, and so we also send those back the next day.

Commander: How do you know if a work is done?

Warden: ███████████ will sign a work, on the back, when it is finished. We collect the works in a file and when there is a substantial enough number of them, say ten or twelve, we'll call his gallerist, ███████████, and she'll come pick them up. According to her, there is an enormous market for ███████████'s works abroad, and the ███████████ Musée in ███████████ is planning a retrospective for next year.

Commander: I still don't understand what his works are.... They are instructions?

Warden: Yes. Usually for drawings, a certain size and material, applied to paper or directly to the wall. Sometimes they're for sculpture or a performance. Instructions for how many people, where, doing what.

Commander: I may not understand art, but how do people know that these drawings or actions... what do you call them—performances?—are the work of ████████?

Warden: Each work is accompanied by an original, signed instruction sheet. Prepared here in the Artists' Prison.

Commander (*thoughtful*): What was ████████'s crime?

Warden: The reason ████████ is here is that the State found some of his early instruction sets grounds for incarceration. There were instructions for cannibalism, torture and forced sexual encounters, among others I would consider more "aesthetic." Like asking people to strip and be covered with paint, or instructions to have another person shoot him or force feed him. It isn't clear whether the State had evidence he had carried any of these out. But there was grave cause for concern that he would harm himself or others.

Commander: The threats were real.

Warden: Yes. Since ████████'s solitary confinement, all his instruction sets have been purely aesthetic. In a sense, you could say his thoughts have been rehabilitated from a criminal mindset to an artistic one. His gallerist, of course, claims that his early work was...juvenilia. In any case, juvenilia or not, the State considered it dangerous, and I believe he still is. My recommendation is that his context be strictly controlled, and that he remain isolated and imprisoned.

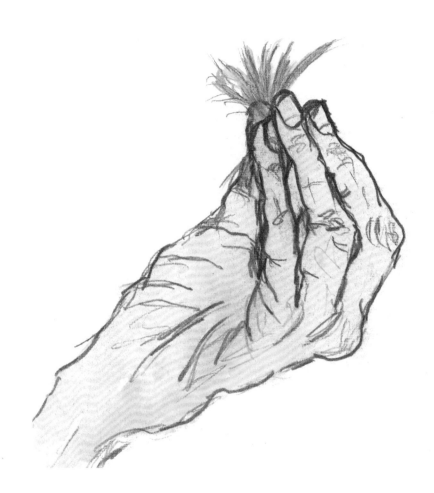

Prisoner #5: ███████████ , **the Rubber Stamp**

Warden: Prisoner #5 is a renowned art critic. His crime was that he murdered his lover. Details of the crime itself are in the file. But the murder was gruesome, and he was committed to life in prison without parole.

Commander: I remember his reviews in the State Newspaper, as well as the trial. Lurid.

Warden: The State still relies on his expertise. In fact, there is no one in the country whose knowledge of the history of art, according to experts, is more accurate than his. You'll see in the file the letters from the director of the State Museum, the chief curator, the senior curator, the associate curator and the adjunct curator, as well as the short handwritten note from the curatorial assistant. There are also letters from the five top galleries in ███████████ , as well as the editor-in-chief of ███████████ . And the Diocese of ███████████ , and the ███████████ family, without whose support in the former state, the museum would not have been possible. Both have reached out discretely to articulate their support.

It was the communications from all these distinguished persons that convinced ███████████ and the State to come to an agreement as it stands now. Prisoner #4 is not an artist, and he was assigned originally to ███████████ Prison, in the ███████████ district, as his crime was premeditated and emotionally driven.

It was there that ███████████ suffered abuse from other prisoners as well as from a depressive state.

After receiving a massive amount of correspondence from various members of the art establishment, the State came to see that the art world was in crisis without ███████████ 's opinion. Nobody could decide for themselves what was good or bad art, and everyone was in disagreement. The correspondence made clear that ███████████ 's opinion was still absolutely necessary for the art world to go on at all.

Unlike the State's other prisons, we're set up to be able to handle art affairs, and so ███████████ was transferred here. When I sat down with him to complete his entrance formulae, ███████████ made it clear that he didn't

want to return to being a critic. I convinced him his role was not to criticize but to validate. He thought about this, then requested two rubber stamps. One says █████ and the other ██. All art institutions submit their images to our offices here. Every day, after lunch, ████████████ comes to my office and reviews the files for validation.

Commander: Are there many requests?

Warden: No artwork is made in the State which doesn't get a rubber stamp.

Commander: But what kind of numbers are we talking about?

Warden: It varies. There are at least ten requests a day. ████████████ reviews them, and then stamps a ██████ or a ██ on each application. They are generally for individual artworks but have expanded to include entire exhibitions, or the admission of a whole collection to the State Museum. Nothing moves forward without ████████████'s stamp of approval.

Commander: Have you had any trouble from ████████████, any behavioral issues?

Warden: He remains antisocial. Recently, the prisoners from the afternoon still-life drawing class petitioned him to organize a group show. I'll never forget his response. "You don't need my approval to be artists." He hissed it. After that he recoiled from any contact with other prisoners. And he doesn't speak to me when he comes to my office.

Commander: What is your recommendation?

Warden: I can't overturn his sentence. Whether or not he is a rehabilitated man is beyond my judgment. I would recommend that ████████████ remain in service of the State, with his rubber stamps. He serves some greater purpose in the world than even I can pretend to understand.

Commander: What do you mean by that?

Warden: A few years ago ████████████ asked for a die.

Commander: As in one of a set of dice?

Warden: Yes. He uses it in his work. He opens the file. Without looking at the image of the work of art, he throws the die, and based on the toss, chooses one stamp or the other.

Commander: I see

Warden: His art connoisseurship is a chance operation. He then looks at the image and writes a detailed justification for accepting or rejecting the artwork—still based on the toss. But this is not every day. Every once in a while I'll catch him studying the images with such fervor and intensity I think it's too bad he has limited himself to only two stamps. But then I know why he does it.

Commander: Does what?

Warden: Throws the die.... Bringing chance into it, choosing whether something is good or bad by the throw of the die, this is what makes him an artist. I've come to believe that critics suffer under the pretense of their misguided apprehensions. They all secretly desire to be artists, even failed artists, yet they cannot take the plunge.

Commander: So prisoner #5 is rehabilitable, then?

Warden: Yes.

Commander: Why?

Warden: Because of the die. He cares too much ...

Commander: And the die takes that away?

Warden: Yes. The die protects him from his own passion.

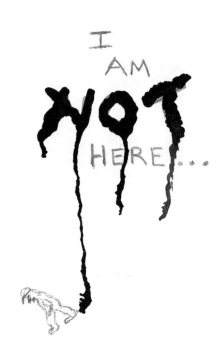

Prisoner #6: ███████████, **the Invisible Prisoner**

Warden: Prisoner #6 is known as the Invisible Prisoner. He is called this because he won't allow us to have contact with him. Or her.

Commander: Rather than the other way around? I had thought that his excommunication was his sentence.

Warden: She/he is excommunicated, but not by me or my staff. We have never seen him or her. One night we received advance warning from the ████████████ Prison. She/he was delivered, but none of my employees were part of the transfer. As you can see from the paperwork, there is nothing there, either.

Commander: Part of the agreement around your testimony is that you have been granted amnesty. Nothing you can say here will be used against you.

Warden: I cannot comment further on Prisoner #6 because, to be honest, I don't even know if he or she exists. Inside the cell could just be a machine for eating. Or a chimpanzee. We deliver a tray every day, three times a day, and it is returned empty. That's the only thing I know. No material requests, no needs. Nothing is communicated. I don't even have a key to his or her cell. The lock was changed.

Commander: So you can't give any form of recommendation?

Warden: No, I can't make a recommendation or pass judgment on a prisoner I have never seen evidence of…. I'm sorry. I would assume that the same people who dropped him or her off might be contacted to pick him up? But I don't have access to that information. Prisoner #6 is a cipher, invisible. How can I explain it when I'm not holding him in the prison?

Commander: Would you like to take a break for water?

Warden: Thank you, but no. I'd rather keep going.

Commander: We'll break for lunch at noon.

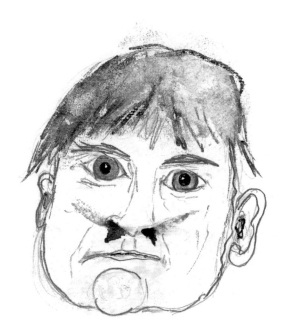

Prisoner #7: ███████████, **the Child Pornographer**

Warden: Prisoner #7 is in frail condition. He rants endlessly about his role in developing a technology now obsolete but known as the "internet." ███████████ is in the habit of talking to himself, and a phrase he often repeats is: "It was me and the DOD, man!"

Commander: If that was the case, then he's been incarcerated for many years.

Warden: My department has looked up the acronym, which stands for the Department of Defense, an entity in the former state that we have no equivalent for. The notes from my predecessor are curious because while they say that ███████████ was subject to heavy therapeutic treatments—electric, chemical, talk—it is clear that he, well, my predecessor, was very… well, moved by Prisoner #7's incessant creativity.

Currently we are reassessing ███████████'s treatment. After the ███████████ process known as "███████████," ███████████ appears to be completely harmless. But we are monitoring his dreams. It is at night that he dreams of children. Violent images. Still, the daily thought monitor gives us nothing to be afraid of. Our recommendation is that, as long as he is wearing the monitor, he be released to live in a sequestered zone.

Commander: But why did he end up in the Artists' Prison? Most pedophiles go straight to ███████████.

Warden: At the time of admission here, his creativity numbers were some of the highest in the State. At the time, the State definition of "artist" wasn't a subjective one. Being an artist was a quantitative measure of creativity. The test was called the "███████████" process, which, as you know, has since been abandoned.

Commander: But why didn't you have him transferred to another prison? Your resources are limited.

Warden: With the monitor on, he has caused no one harm, and no other prisoner here has harmed him. On an electromagnetic level, ███████████'s

dreams have never escaped these prison walls. In effect, he's been neutralized. If ███████████ is released to live in a sequestered zone, the only recommendation is that the walls will have to be thickened to thirty-seven centimeters, the minimum to contain electromagnetic threats. That way, no matter how troubled ███████████'s dreams become, they will always be contained there.

Commander: What is his creative value?

Warden: It's a sum zero, sir.

Prisoner #8: ████████, **the Coincidence Artist**

Warden: Prisoner #8 sees coincidences in everything. At group meals, dinner in particular, we have observed how ████████ regales the other prisoners with her stories. Measuring blood pressure and eye movements, it seems she cheers other people up. With her magical thinking and belief in underlying connections, she gives hope and meaning to what can become a fairly routine existence here at the prison.

Commander: What do you mean?

Warden: We here at the Artists' Prison, and the State, as you know, don't condone organized religion. But we see how strongly impacted the prisoners are by ████████'s belief in coincidences. Searching for and believing in patterns and causes leads to a better-behaved prison population. As a result we started creating coincidences.

Commander: Like what?

Warden: A scratch on the bottom of the cafeteria tray. The same number of potatoes on a plate. But not too many. A pattern, but just on the edge of recognition.

Commander (*flipping through the file*): But what was ████████'s crime?

Warden: She hasn't committed one yet.

(*The Commander looks up.*)

Warden: In 19█ the State created the Extraordinary Speculation Program. During the ten years of the program, many people were imprisoned because of traits—race, sex, class, religion, height ...

Commander: Height?

Warden: In 19█ height was believed to help prognosticate behavioral traits, such as success, breeding potential, and other outcomes. ████████ was imprisoned because she ranked high on the tests for ESP.

Commander: ESP?

Warden: Extraordinary Speculation, sir.

Commander: So ██████████ has never committed a crime?

Warden: No.

Commander: Well, it goes without saying that ████████ must be released immediately. Under current State law, there are no grounds for holding her here.

Warden: Sir, for the record, I'd like to say that there are several other prisoners who were imprisoned under ESP.

Commander: They must be released as well.

Warden: But since being imprisoned, many have committed heinous crimes that require, well, that they be kept inside.

Commander:

Warden: I understand, sir. But I recommend that we move forward on a case-by-case basis.

Commander: Let's break for lunch. We'll resume this discussion afterward. (*pushes intercom*) Guards! (*to the Warden*) They'll accompany you to the lunch room.

Lunch

The Warden stands in line at the cafeteria, where the food is standard issue. She is surprised by the variety of vegetables for the time of year. While the other employees are not unkind to her with their glances and gestures, they keep a polite distance and avoid any direct contact. Her light gray suit distinguishes her from all the officials from the State department, who wear charcoal-colored uniforms.

She sits alone near a window looking over the asphalt parking lot on the north side of the building. The guards assigned to her eat at a table nearby.

She can't help but notice, as she moves her plate off her red lunch tray, a small carving of a rabbit, facing forward, its eyes wide open, and its paws, like hands, holding a carrot.

She realizes lunch is over when the next shift of State employees begins to arrive for the one-o'clock rush. The guards stand up at the same time. One clears the trays; the other comes to her side. "I think it's time," he says.

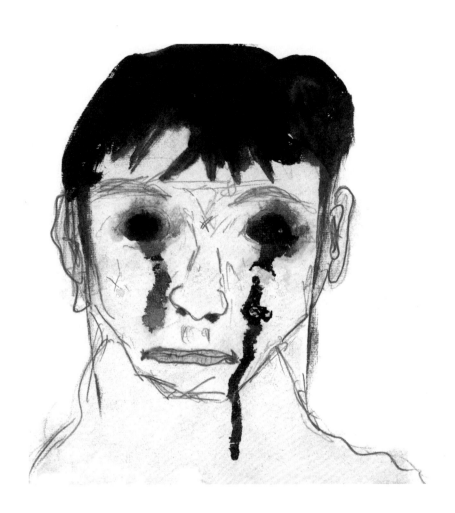

Prisoner #9: ██████████, **the Color-Blind Artist**

Commander: Let's resume

Warden: Prisoner #9, the Color-Blind Artist. Imprisoned in 20█ for pirate radio transmissions that falsely described the world. The State handed down a prison sentence of five years, for propaganda. ██████████ has been an exemplary inmate. He will be released in two months, after completing his sentence. His broadcast license has been rescinded, but during his time here at ██████████ he has been retrained to work with his hands. Tools. We've arranged a position for him as a mechanic, at ██████████ Motors.

His color blindness should not have any impact on his future employment.

Commander: Anything else?

Warden: No.

Commander: Next, then.

Prisoner #10: ███████████, **the Tattoo Artist**

Warden: Prisoner #10 is both hemophobic, fearful of blood, and trypanophobic, fearful of needles. Her punishment was that as supplies she would only be given tattoo ink and needles. At first she wouldn't touch them. Then, tentatively, she took up a needle. The first tattoo ████████ gave herself was a point. The second was a line. Now she draws anything from her imagination. Every part of her body she can reach is covered.

In 20██ ███████████ requested to tattoo other prisoners, and permission was granted by my department. To date, she has tattooed thirty-one of the prisoners and fifteen of the department staff.

Commander: Is that permitted?

Warden: We've made the exception to prisoner-staff interactability in this case.

Commander: And her crime? ... (*glances through file*) Oh, yes, I see. ████████ ██.

Warden: ██ ███ ██████.

Commander: This is an unusual case. What should become of her?

Warden: ███ ██ ████████████████████████████████. The rehabilitation would be complete at that time.

Commander: That is an unusual recommendation, but I'll note it here.

Prisoner #11: ████████████ **, the Masturbator**

Warden (*looking up*): To be expected, I suppose. We thought she'd get tired of it, but in fact putting her in isolation has made her even more onanistic.

Commander: Like an addiction?

Warden: Yes.

Commander: You haven't, since this deposition began, spoken about any inmates with problems with drugs or alcohol.

Warden: While I have both noted here in ████████ 's intake formulae, I can perceive no real correlation between significant substance abuse and ████████ 's addiction to masturbation. These individuals, prisoners at ████████ , all demonstrate addictive behavior, but sublimation is more common in artists than addiction.

Commander: So ████████ is in the Sublimation Program?

Warden: Yes. And it has been quite successful. During times of high sexual excitement or need she has learned to sublimate her feelings into a form of creative expression. Through good behavior she has earned the right to use the prison's camera. After reviewing her work over a period of months, the medical team ascertained that there were images without masturbatory content, and for these she has been given an exhibition.

Commander: Inside the prison or out?

Warden: Inside. We have a small gallery for prison artworks by the entrance. ████████ doesn't have gallery representation in the outside world. But it's my hope that someone might come to the opening ...

Commander: These prison openings ... do people come from the outside?

Warden: Not very often, no. It is so far removed, you see, and requires extraordinary effort to get the right permissions. But in this case, it doesn't matter.

Commander: Why not?

Warden: Because I went through the files. Prisoner #5, the Rubber Stamp, has given her work the █████ stamp. As soon as we circulate those documents to the world, we'll release ████████, and she'll have no problems with her career. It's guaranteed. Apparently there is some unexplored correlation between masturbation and "great art" worthy of the marketplace.

Commander: What crime did she commit? As I can see here, she was interned at ██████████ when she was just sixteen years old.

Warden: It's hard with juveniles. It was thought that cases such as hers, well, that it was better that she become an artist rather than a criminal. That was the psychological assessment at the time. We see it as very backward now, of course. I don't think the experts had seen behavior like this in such a young girl. Masturbation at the levels she engaged in has always been seen as standard for young men. That's why she ended up here.

Commander: I'm trying to ascertain whether the Artists' Prison is in fact a prison or a mental health facility.

Warden: The line, as you draw closer to it, Commander, becomes very fuzzy.

Prisoner #12: ▮▮▮▮▮▮▮▮▮, the Artist We Call the Alchemist

Warden: ▮▮▮▮▮▮▮ believes that he can turn anything into gold. He is constantly asking for the materials he needs for his experiments—sulfur, dewdrops, iron oxide, silver shavings, crystal, lead, horse dung. Our department has request forms for materials, and the prisoners are well aware of the protocol. ▮▮▮▮▮▮▮ follows the protocol, but we are never able to fulfill his wishes, as they are far beyond our budget.... I've often wondered if he would be able to make gold if we provided him with what he asks for.

Instead, denied of his requests, ▮▮▮▮▮▮▮ believes that he can turn his own excrement into gold. We hold him in a cell specifically equipped to be hosed down. This becomes necessary about once a week when he has been conducting his experiments.

Commander: Would you say ▮▮▮▮▮▮ is crazy?

Warden: The Alchemist copes with his own failures with such extreme optimism that it is hard to know. He is certain the next experiment will be a success. On a personal level, his worldview is convincing. That anything, with the right approach, can be gold. Like the Coincidence Artist, others around him start to believe it. He buoys the spirits of the other inmates and even, I must confess, of the staff.

Commander: It says here ▮▮▮▮▮▮▮ is eligible for parole.

Warden: Yes, with the contingency that he not return to his former profession.

Commander: Which is what?

Warden: Banking.

Commander: What will he do instead?

Warden: The State's professional placement program has had him tested and recommends a position in sales. The Alchemist is not pleased by this result. One symptom we've noted in our prisoners is a transference.

Whether they were or weren't artists to begin with, they certainly conclude they are artists after a certain period of time here. In █████████'s case, he believes that he can make gold out of excrement. Believes it. The Rubber Stamp told ███████ about the case of a prisoner called the Scatologist, who left the Artists' Prison years ago, years before my tenure. The Scatologist did figure out how to make his excrement into gold, by canning it. "Merde d'artiste," he called it. Most of those cans are in the collections of museums all over the world. Inspired by this real-world example, the Alchemist insists that he can literally turn his excrement into gold, but that it is us who fail to understand his gift.... I don't see him as a potentially harmful agent, and I recommend that he be released.

Commander (*scanning file*): What was his crime?

Warden: Speeding.

Commander: He was imprisoned for such a minor infraction?

Warden: He was arrested for speeding, and then the State realized who they had in custody. A man wanted for creating the largest Ponzi scheme in modern memory.

Commander: And you'd recommend letting him go?

Warden: Yes. He's harmless now. The financial technologies of his former profession have far surpassed his abilities to manipulate them. We've assigned him to a job selling cars for the State.

Commander: But there's no recommendation for a lobotomy ... or even a monitor.

Warden: We've found that psychology is more effective. In exchange for his job at the car lot, we've set up a laboratory and all the ingredients he's requested. The deal is that if he can produce gold, he'll never have to sell another car again.

Prisoner #13: ███████████, the Panorama Artist

Warden: ███████████ loves views. She creates them everywhere. Her murals cover a wall in the exercise court as well as the cupola of the dining room. The paintings are beautiful and innocuous until you get up close, and then you see that the images are made out of small ███████████ ███████████. Therefore the only way to safely see her work is at a distance. On Sundays, visiting days at the prison, the families and visitors of other prisoners sit across the courtyard and gaze at the mural. At a distance, even I admit, it appears beautiful. Little do they know its essence is of the most insensitive evil. This puts the State in a conundrum. Where can the Panorama Artist work? It seems only in prison. The other inmates don't mind. They know the truth.

███████████ was imprisoned because of her art and remains exactly the artist she was before being incarcerated. It is my recommendation that she remain imprisoned. There are enough walls inside the State's penitentiary system that she could be moved from prison to prison, under the auspices of an "artist-in-residence" program of some sort. She's already fifty-three years old. Working in peace, she might paint for another twenty or thirty years at most. Each view, each panorama, takes about five years to complete. After we complete the photography for her records—at a distance, of course—we will be able to transfer her to another prison. At that time we can paint over her work. At her death, each view will have been painted over, and it will be as though she never existed.

Commander: Fine. (*looks at watch*) We'll break for the day at 4 p.m. and resume tomorrow.

Warden: As you wish. May we take a short break now, please?

Commander: Yes. Fifteen minutes.

Bathroom Break

The guards walk the Warden to the women's bathroom. One guard hands her her purse.

Inside the toilet stall, the Warden urinates, flushes the toilet and arranges her clothes.

In front of the mirror she washes her hands and inspects her face. She opens her purse and looks for something: lipstick. She applies it, touches her lip with her index finger and then leaves the bathroom, returning her purse to the guard who handed it to her.

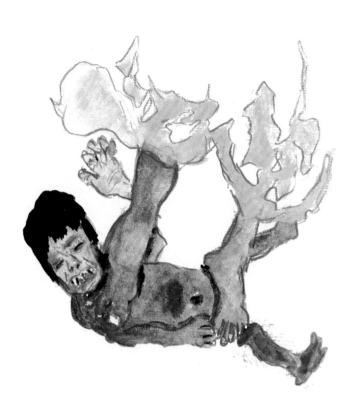

Prisoner #14: ███████████, **the Child Murderer; Prisoner #15:** ███████████, **the Mother Murderer; and Prisoner #16:** ██████████, **the Mass Murderer**

Warden: I've grouped these three inmates together because they are so predictable. They all committed heinous crimes with motivations based on un-worked-out issues of abuse and desire from their childhoods. ███████████, ███████████ and ████████ are our most successful students in the art classes. They are prolific and well behaved and create, in quotes, "interesting" artwork based on their pathologies and the desire to please or manipulate the medical teams here at the prison. I've always argued that they're in the wrong prison.

Commander: Why is that?

Warden: Just because they make things well doesn't mean they are artists. In their cases art is their therapy and how we control them, their behavior and time. But their contributions are not art. In fact, any reward for their work could lessen our understanding of them as the basest of criminals. I recommend that they be transferred to ████████████, the State's highest-security prison, and that they continue their therapeutic art classes there.

Prisoner #17: ███████████, **the Misogynist**

Warden: The Misogynist hates women, or so he says. Like the Alchemist and the Scatologist before him, ███████████ is obsessed with his own excrement. But unlike the Alchemist, who really is a scientist at heart, and the Scatologist, who was quite formal in his approach, the Misogynist is a performer. He seeks to disgust, confront, challenge and upset. There is a saying here at the Artists' Prison: "Don't get into a pissing contest with a skunk." That's the Misogynist. He seeks to go lower than anyone else would go, but is not fueled by hatred against women, per se. His self-definition comes from antagonizing anything womanly or feminine, words whose definition shifts according to his audience. Ultimately, he is a competitive narcissist whose self-definition comes in the form of antagonisic hatred.

He is, as a result, a danger to himself and others. While ███████████'s crimes have never gone beyond public nuisance, stalking and indecent exposure, the State concluded after dozens of trials that it was more cost effective that he remain incarcerated without parole. I agree. The smaller his effect, the better.

Commander: Is there no treatment? It sounds rather puerile.

Warden: The treatment for this kind of behavior is usually to instill some sort of sense of humor within the prisoner. The brain scans (*holds them up*) reveal, unfortunately, that ███████████ is missing the necessary wiring. There's nothing we can do in this case.

Commander: Your recommendation?

Warden: Off the record? An accident. He could slip in the shower.

Commander: And on the record?

Warden: My recommendation is that ███████████ remain incarcerated.

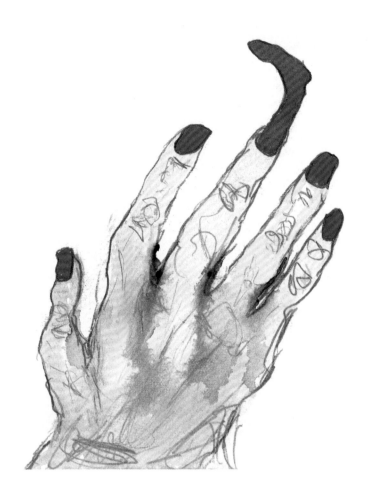

Prisoner #18: ██████████, **the Feminist**

Warden: In many ways Prisoner #18 is the mirror image of the Misongynist. She too is motivated by the performance of her beliefs, in her case, that men, or a masculine principle, have oppressed women, or a feminine principle. Everything is personal. Over the last few years we've studied her secretly through the observation window in her cell. She, like the Misogynist, is most content when she is alone. But when an audience is introduced, so is the theater. The Feminist is addicted to the attack and the reactions she gets, watching men in a defensive mode. It is no surprise that the Misogynist and the Feminist are of the same generation. They're like psychic twins, having inherited parallel belief structures from their cultural context.

Commander: But her behavior as a prisoner?

Warden: The Feminist is a relatively easy prisoner. Her crimes were simply indecent exposure and prostitution, an activity she describes as "empowering." We've held her for as many years as we have because she has requested to stay. It's as though she needs the institutional framework to function.

I recommend that she be released. Her behavior can be described as proselytizing at worst. And her impassioned diatribes against men can be quite moving, to tell you the truth. (*gathers herself*) When informed that she would be released, ██████████ asked that she be transferred to a brothel.

Commander: But surely she knows those don't exist anymore.

Warden: We've begun the briefing for reintroduction. We've told her how gender and sex roles have shifted, the many changes in human biology, et cetera, et cetera. I think once she's released her five senses will triumph over her ideology. The job placement office has been alerted and already has her file.

Prisoner #19: ███████████, **the Soap Artist**

Warden: ███████████ steals soap from the showers. His behavior is inspired by an ███ soap advertising campaign from his childhood. (*singing*) ████████ ████████ ████████ ████████! He spirits the bars back to his cell and spends hours carving them.

We used to have liquid soap in the showers, but enough artists tampered with it or ingested it—the Water Painter, for example, to add bubbles to his compositions—that the medical department requested we switch back to bar soap. We do everything, as you know, to minimize the likelihood of poisoning and suicide attempts. To our surprise, Prisoner #19, who had never demonstrated any interest in anything whatsoever, completely apathetic to life, began stealing the soap bars the day we stocked them back in the showers. We put him under observation to see what he would do with them.

Commander: And?

Warden: Carving.

Now ████████████ is regularly asked to display his sculptures at the prison exhibits. His small forms—of trees, mushrooms, cats, dogs, only the most banal of subject matter, really—are popular with both inmates and visitors. This has given ████████████ a real sense of satisfaction.

How ████████████ carves the soap is a complete mystery. He is not allowed knives or any sharp objects and routinely undergoes body and cavity searches. You'll remember his trial, for the murder of ████████████ ████████████.

Commander (*looking at file*): Yes, I see.

Warden: I recommend that he be transferred to the State's medium-security prison, and that soap bars be provided regularly.

Commander: Could it be with his nails?

Warden: I'm sorry...?

Commander: With his nails ... how ▮▮▮▮▮▮▮ carves the soap?

Warden: I hadn't thought of that. I'll have the medics check his fingernails.... If so, that makes the carvings even more remarkable.

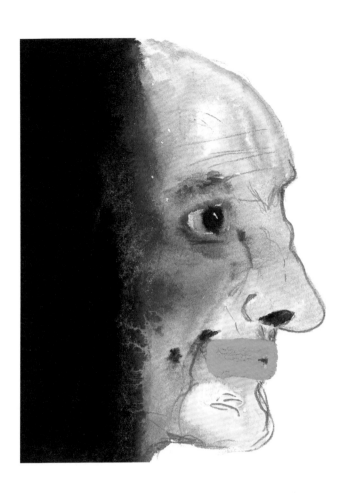

Prisoner #20: ████████████, the Orange Artist

Warden: ████████████ believes only one thing, that "orange is the new black," a phrase we've never been able to trace the origin of. It seems to have been a colloquialism that had no author in the former state. The research department found that a French author, Paul Eluard, once wrote that "La terre est bleue comme un orange" ... the earth is blue like an orange. I made the mistake of telling this to Prisoner #20; as you know, his mother tongue is what was known as French. He then submitted a request to have his cell and furniture painted orange, which we agreed to do, on account of his good behavior.

Commander (*looking over file*): And it says here that he only eats orange-colored foods.

Warden: Carrots, oranges, papaya, squash, salmon. He'll eat eggs scrambled with ketchup. ████████ also requested an orange uniform. This request was denied, as at ████████████ all prisoner uniforms are white.

Commander (*flipping the pages*): So many pages of this dossier are redacted that I'm having a hard time understanding who the prisoner is or what his crime was exactly.

Warden: ████████████ was the president of ████████, a former state and French colony. He was extradited in 19██, after losing a war with our State. I'm not a student of history, but I can say I have no idea if the charges—reportedly genocide, and so on—held against him are real or created in order to keep him in prison. If you turn to the last page, you can see the special directive to satisfy every need or whim of Prisoner #20, without putting him in too much danger.

Commander: Can you clarify this?

Warden: Supposedly the danger to ████████████'s life is so great that we have taken measures to make sure no would-be assassins infiltrate either the prison staff or prisoner population.

Commander: I'll contact the ambassador. The regime has changed several times, perhaps enough for memories to have abated. Perhaps ███████ can be returned to his home country?

Warden: Yes, with one concern: ████████████████████████
██
████████████████████.

Commander: Yes, a good insight. (*pushes button, speaks into microphone*) Henry? Can you track down the ambassador of █████ and set up a meeting for next week? My office. (*releases button*)

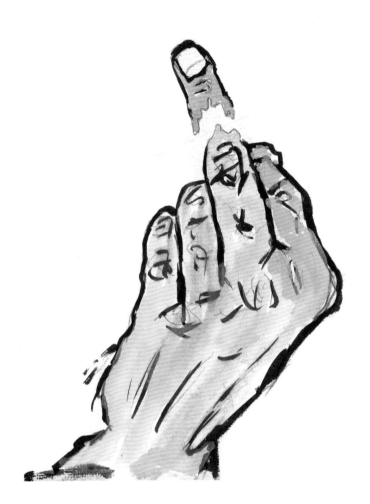

Prisoner #21: ███████████, the Religious Zealot

Warden: Prisoner #21 is an exemplary prisoner, spending each and every minute he can in the art room under supervision of our technician, Mr. Alberto. ██████████ has created a new illustrated Bible, or at least part of it. The New Testament. I've seen the illustrations myself; they are quite beautiful. However, it should be noted that the Christ figure bears a striking resemblance to ██████████. If you read Mr. Alberto's report, you'll see that ██████████ sometimes still preaches to an imaginary group of followers. This at first provided some humor to the other inmates in the art room, but they soon found it irritating, and violent threats followed. Prisoner #21 agreed to keep his sermonizing to times when the art room is unoccupied by anyone other than a guard or Mr. Alberto, who, religious himself, doesn't seem to mind listening. I can't blame him. After hours of small talk about the color orange or the importance of panoramas, some fire and brimstone can come as a relief.

Commander: What is the plan for his release?

Warden: As religion is outlawed by the State, we've sought to find another environment that is more tolerant. The Brothers of Saint ██████████, a monastery in eastern Egypt, have accepted ██████████ into their custody. They were impressed by his artwork and have expressed the desire to have ██████████ illustrate the Old Testament, to keep his work with the other manuscripts in their library. ██████████'s zealotry doesn't frighten them. They don't understand a word of English, and ██████████ doesn't speak Aramaic or Arabic. I don't know why we didn't think of this sooner, keeping him out of earshot. He could have been sentenced to Egypt earlier.... But then he wouldn't have become an artist. This is a case of someone becoming an artist while here at ██████████ Prison.

Commander: What was he convicted of?

Warden: Selling Bibles door to door. Proselytizing.

Commander: Wouldn't ██████████ prefer to stay here, in our country? Surely he could control himself. Doesn't he have friends or family?

Warden: No, he has no family, never married. Prisoner #21 is convinced that going to Saint ██████████ is God's will, that he'll practice God's work in Egypt.

Commander: When does he go?

Warden: Next week.

Commander: We have time for one more.

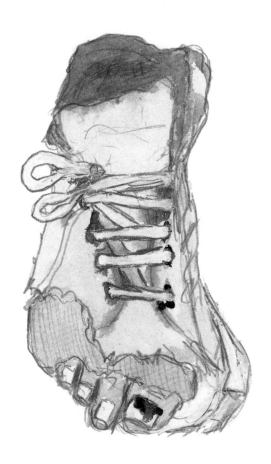

Prisoner #22: ███████████, the Cobbler

Warden: Prisoner #22 is a shoe artist. He makes shoes out of any material available. The shoes he creates aren't like any shoes you've ever seen before. They're intuitively made. They fit the wearer perfectly. Bubbles, paper, air ... it doesn't matter what material, ███████████ can transform it into a perfect pair of shoes.

Commander: And it says here human-skin shoes, human-liver shoes ... disgusting.

Warden: People have very different ideas about what luxury is. The Cobbler was known for making shoes out of anything. He helped us catch some of the other prisoners, like ███████████ and the Mother Murderer. He was given a bargain: to give the State the identities of his most extreme customers in exchange for being inside with us, and being able to continue making shoes.

Commander: For other prisoners?

Warden: No. The Cobbler makes shoes for private clients. We vet the requests. The shoes have to be poetic in nature—I mentioned paper and air, but he also makes them out of flowers, cake or dust. Or out of normal shoe materials: leather, fabric, wood.

Commander: He's being released.

Warden: Yes, that's my recommendation. He's useful to the State as an unwitting informant. Just last week we were able to identify ███████████ through his help.

Commander: The arms smuggler?

Warden: He ordered some boots out of iguana skins, which are not illegal in and of themselves, but could only have come from his family's estates. We were able to capture him the next day. My suggestion, which I believe the State is in the process of approving, is to set up the Cobbler with a new workshop. The right people will hear about it. The State will monitor his clients carefully.

Commander (*glances at watch*): That will wrap up our session for today. We will continue tomorrow.

Warden: Yes, sir.

Commander: (*pushing the intercom button*) Guards? We are concluding today's session. (*to the Warden*) And your shoes?

Warden: Standard issue.

Commander: Yes, I see. (*to intercom*) Closing the deposition room for today. Prisoners #1–22's case files are complete. Please deliver the second batch for tomorrow. We resume at 9 a.m.

End of the Day

The Commander watches as two guards enter the deposition room. The Warden steps back from her podium and holds out her arms to the first guard, who handcuffs her. They process out, a guard followed by the Warden, with the second guard behind her.

The Commander can't help but look at her shoes. They don't appear out of the ordinary.

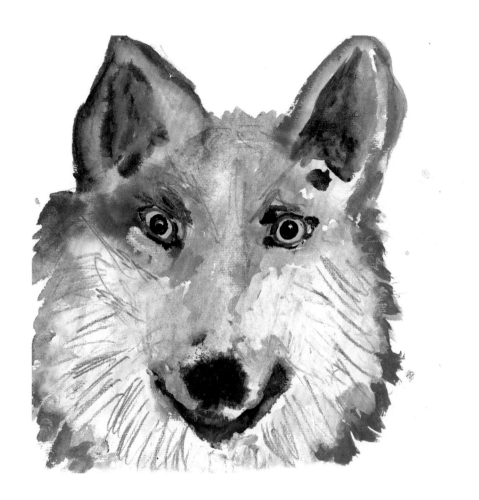

Prisoner #23: ███████████, **the Magician**

Commander: Good morning. Like yesterday, we will break for lunch at noon. My hope is that we can make it through the rest of the files before the end of the day. Please begin.

Warden: The Magician casts spells. We keep close track of them, recording him in his cell and during outside activies. Though now he tries to conceal them from us, it's difficult because he has to say them out loud. With our sonic technology we can capture even the faintest whisper.

Commander: I didn't know the State believed in magic.

Warden: The State is committed to compiling data. For example, in the third quarter of last year, the Magician had a 72 percent success rate with his spells. Granted, these are the ones that we could actually record. We believe that this rate of success is much higher than most so-called magicians. Let me give you a sense of some of his most recent incantations. (*lifts sheet of paper*) Clogged toilet, middle stall, women's bathroom near the dining room.... Successful. Late delivery of linen service, by one hour, Wednesday morning.... Successful. Water turned off in staff kitchen and bathrooms, Saturday at noon.... Successful. Electrical failure, cell block 17A, midnight, Monday.... Unsuccessful.

The State is interested in the Magician's work. If there's some practical application as he hones his skills.

Commander: Hmmm.

Warden: It appears he has more success with spells about water than electricity. It's an unusual case, even for us. I think that ██████████ should be released. We've been observing him for five years. We can continue to collect data after his release.

Commander: Has he completed his sentence?

Warden: Yes. Five years served for ████████████████████ ████████████████.

Commander: That doesn't sound criminal.

Warden: Given ███████████████████████████
███████████. And he failed. I'd like for him to have a chance. We couldn't make him into an artist here. Perhaps he'll be able to take what he's learned and transform it into something. He knows how the system works. The Rubber Stamp, the galleries, the.... Now it's up to him.

Commander: Perhaps he could cast a spell?

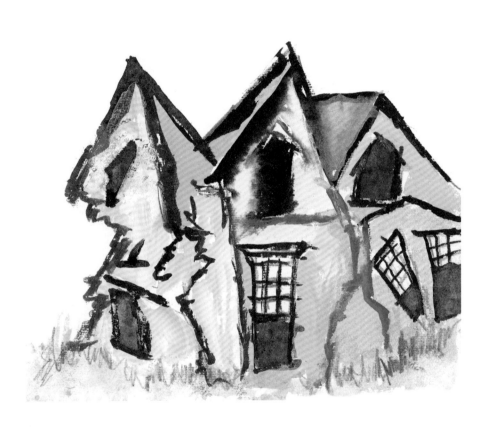

Prisoner #24: ████████████, the Architect

Warden: Prisoner #24, the Architect, had an idea. You must be a fan of the writer, Jorge Luís Borges? A favorite of our Supreme Leader.

Commander: Go on.

Warden: In one story, Borges tells of a map maker who made all his plans at one-to-one scale. The maps became so large, they began to overtake and cover the places they were meant to represent.

Commander: I read it in school. "Of Exactitude in Science."

Warden: What most of us saw as child's play, the Architect took on as a mission. Originally very successful in her practice—you'll remember, her firm ████████ ████████ built the Symphony Hall—her success made her more and more ambitious. She began making her plans larger in scale, first one to ten, then one to four, then one to two.... Like Borges's cartographer, the materials began to take over. First paper and then canvas. If you'll remember, the Supreme Leader went to ████████'s offices to see the latest plans and found half of her mausoleum, for that's what the Architect was building, laid out in real-life scale. Our Leader was shocked, as you can imagine. She recognized the disorder from Borges and wrote to me about the Architect in a letter dated July 12, ████. The Architect was interned here almost immediately after.

Commander: What is her behavior like?

Warden: We let her draw. She is allowed to outline everything in pencil. She's harmless. We see her planning the prison—drawing at the corners, and the seams where the walls meet the floor.

If she's released, she'll do the same. I can imagine her, tracing the corners and edges of every building in the capital. My sense, and again, this is my opinion, is that the Supreme Leader has tried to protect the Architect's reputation. The Symphony Hall and the mausoleum—as you know, currently under construction—still bear ████████'s name, although she is not consulted. It would be an embarrassment to the State if people learned of her true condition: that she had taken literature for life. I recommend that she be kept inside. She'll remain harmless, and relatively out of the way.

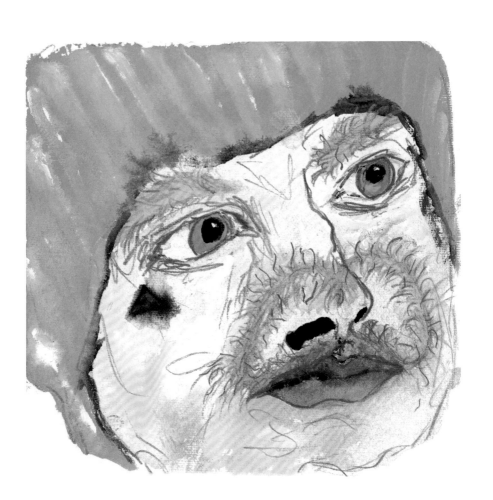

Prisoner #25: ██████████, **the Moustache Artist**

Warden: Prisoner #25 is a woman we've always called the Moustache Artist. Since entering ██████████ in 20██ for the crime of poisoning her husband, she has been obsessed with her upper lip. I realize it's unprofessional of me to say this, but I find the case rather funny. ██████████ is trying to grow a moustache. How she's going about this is a mystery, as she hasn't changed her diet, and we haven't provided her with hormonal treatments. But at every opportunity she looks at her upper lip in any reflective surface, be it a mirror, the side of the toaster, a pair of sunglasses. She also wears fake moustaches, made out of any material she can find: felt from the corners of her uniform pockets, a leaf from a tree found in the courtyard, a piece of toilet paper. She wears these surrogate moustaches without any sense of irony, or humor, for that matter. Sometimes the staff find it very difficult to keep a straight face. Last week she wore mustard for the whole afternoon after lunch, and the next morning her upper lip was dyed the faintest shade of yellow, which she wore with pride.

Commander: Your recommendation?

Warden: That no mistake be made: she's an unsympathetic killer, and we shouldn't let odd behavior or stunts distract us from that fact. She's utterly capable of keeping up a ruse for months or even years, as she did with her husband, convincing him that the symptoms of poison were a form of cancer.

Commander: It says here in her file that he didn't die.

Warden: She doesn't know it.

Commander: But she must know by now that cancers have for the most part been eradicated.

Warden: Yes, she knows that. But she thinks she got in under the wire, before the cure. That she got away with it. She expects to be kept in prison for life. That's what she was sentenced to.

Commander: And her husband?

Warden: A new name, a new identity. He has been protected by the State.

Commander: Doesn't it seem curious to you?

Warden: What, sir?

Commander: That this woman would spend a life in prison, wearing moustaches, when in fact her crime was a failed murder.

Warden: There's more to it. ████████████████████
██
██.

Commander: Ah, I see.... These are interesting cases, aren't they? We can't judge her from the viewpoint of another time because we fundamentally don't understand it.

Warden: In that sense, is the law relative?

Commander: Far from it. The law is timeless because it is living. It continues changing, growing. It is in the moment, always.... So what do we do? An inmate is held for a crime that wasn't successful. (*reads the file*) For twenty years.

Warden: She thinks she is a murderer, and so she is. She should be sent to ████████████, with no change in her status as a convicted killer.

Prisoner #26: ███████████, **the Echo Artist**

Warden: Prisoner #26, the Echo Artist, tries to create echoes in his cell, bouncing sounds from every angle, using every material. By observing him, we know he throws his own voice off the walls, the bowl of the toilet, the surface of the stainless steel mirror. In conversation, he's thoroughly annoying. He repeats everything you say, almost in a whisper. Most of our staff won't work with him, because the result is that, and I quote, "I want to kill him," "listening to him makes me want to strangle him," "I want to slam his head against the wall," et cetera. These are from reports by prison staff members who have filed requests to avoid contact with this particular prisoner. Why? Because ███████████'s crime is making people around him flood with anger, making their blood boil to the point of boiling over, making those who have contact with him into killers themselves. And once they attack, he simply moves, very quickly, to defend himself.

Commander: His record is impressive. Twelve murders, all of them acquitted as self-defense?

Warden: All of them. He reminds me of a child taken to adult extremes. Every child goes through a stage of mimicking—as a parent, it's the most infuriating thing. It raises your hackles and pushes you toward the edge. But as a parent, you have to come back from the edge and gain control of the little monkey teasing you.... ███████████ is like an adult child. His mimicry is far from innocent. Again, we're lucky we haven't had any incidents here at the Artists' Prison. Just some pushing and shoving, bruises and a broken rib. Nothing major.

Commander: So he remains locked up?

Warden: Yes. Historically, there was one use for him. It's been a long time now, as this kind of methodology is rather outdated. There is no paper trail. It was simply called the Echo Chamber. No one ever lasted longer than a week as his cellmate. Ever.

Commander: Ah, I see.

Warden: The State keeps him in the Artists' Prison until there's a need at one of the other penitentiaries. Think of it what we may, it's an effective

solution. But there hasn't been a need in a long time. ██████████ is, for all intents and purposes, getting older and less fit. Retired. In a few years, I imagine he won't be able to defend himself.

Commander: Is he aware of his own condition?

Warden: Once, in a rare moment when he didn't repeat back what I had just said, he whispered, under his breath, that he requested a new assignment. I pretended I didn't know what he was talking about. Was it a suicide attempt? I don't think he'd make it through another Echo Chamber.

Commander: Duly noted. Any need for a break?

Warden: Not at this time, sir.

Prisoner #27: ███████████, **the Exhibition Artist**

Warden: A studio visit, as you may know, in the outside world, is when an artist invites a dignitary or other important figure to visit and look at the work presented there. We call ███████████ the Exhibition Artist because she is always waiting for such an encounter.

Commander: But surely the prisoners at ███████████ don't have studios?

Warden: No, just the shared art-making space in our classroom and the gallery where some inmates earn the privilege of showing their work. No, ███████████ doesn't have a studio, but we let her take her drawings back to her room, and she sticks them up on the wall with sticky-tack. Tape, as you know, is not regulation for cell use. She is allowed to keep the paper overnight because the medical team has assured us that she won't use it to slit her wrists. She hangs her drawings up on the wall and waits for a studio visit, endlessly.

Commander: Does anyone come?

Warden: Yes, sometimes I allow the staff to visit her. I feel sorry for her, that's all. I've passed on some of her drawings to the Rubber Stamp but even with the die he has stamped all of them ██, and it would break her to find out. ███████████ has requested to have the door to her cell left open during certain hours, but we've explained that we can't be vigilant all the time, and that something might happen to her. Her safety is at risk. As you know, we keep male and female-born inmates on the same corridors. Studies proved that pheromones and hormones are an effective means of regulating the behavior and mental health of the inmates. ███████████ would easily be overpowered by a male inmate, she's so birdlike and rather naive.

Commander: I'm curious about her crime. It says here: "paperwork lost."

Warden: Yes, I'm afraid her papers were lost. Or at least that's the official line. ███████████ was part of a test program conducted in 20██. As you might remember, both the efficacy of the Artists' Prison and the excellence of the State Academy of Fine Art were being questioned. It was decided that three applicants for the Academy would be switched with three recently convicted criminals. At the last minute, two of the accepted art students

decided on other career paths, and so the experiment was kept to one exchange. ████████ was brought here to the Artists' Prison, and has adapted well to the systems. Apart from the desire for an exhibition, she has never questioned our rules or behaved in a manner that required discipline.

Commander: And she never questioned why she wasn't at the Academy?

Warden: Because of the discretion here in naming things, I don't know if she knows.... She could leave at any time if she wanted to.

Commander: And the other? The criminal?

Warden: Oh, ████████████? I'm sure you've heard of him. He graduated from the Academy with a master's degree in fine arts, and was given a show at the State Museum within a year of graduation. He's considered one of the State's great artists.

Commander: But didn't he shoot his wife in the head?

Warden: Yes, as part of a piece of art. It happened out of the country, in the state of ██████, and under that country's laws was considered an accidental death. What's more, it's become part of his lore.

Commander: But this woman...

Warden: ████████?

Commander: Yes. The Exhibition Artist. You can't possibly keep her?

Warden: We can't possibly graduate her from prison, either. She's one of those who haven't become artists here. She follows the form, but there's no creativity.

Commander: You must start leaving the door open.

Warden: Sir?

Commander: I see no other solution. Until the prison closes. Give her a chance for an encounter. For something to happen. Otherwise she must be released to the Academy.

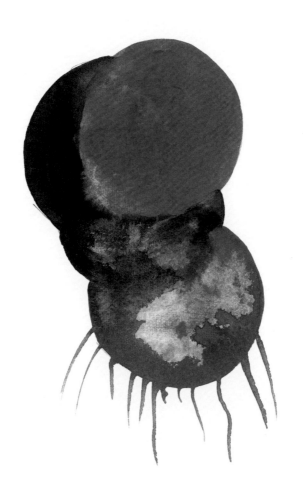

Prisoner #28: ████████████, **the Polka Dot Artist**

Commander: Let's break for lunch after this case.

Warden: Yes, all right. (*reads*) Prisoner #28, ██████████, known as the Polka Dot Artist. She draws circles everywhere, all the time, of two uniform sizes, tracing the plastic cups medication is dispensed in and plastic mugs from the dining room. We tried stopping her, but she spirits them out of the dining room one way or another. In the medical assessment you'll see that she has stuck them up both her vagina and rectum several times. Once we allowed her her tools, she agreed to stop drawing directly on the walls.

In the art workshop, ███████████ has a dedicated space. She works on paper. The prison system can't afford to purchase more expensive materials unless the prisoner is able to pay for them herself. Her works are obsessive, delicate, layer upon layer of circles. Her preferred materials are pencils and graphite mixed with wax in grays, light blues and occasionally a butter yellow.

They are beautiful. I've presented them to the Rubber Stamp several times, but he refused to roll the die. I'm amassing quite a collection of her work in the vault. For the State, of course, not for myself. At the right moment, she'll be discovered. Toward the end of her life, no doubt, after she's eighty. I only hope she'll be able to enjoy it.

Commander: Do you have a personal relationship with her?

Warden: Oh, no, not with her, or any of the inmates. But I watch. Over the years I've learned to trust my sense of aesthetics. She's the only prisoner I've extended myself for, as it were. Trusted in their vision. She has no idea that I'm her benefactor in the system, and that's how I'd prefer to keep it.

Commander: And her crime is?

Warden: She was slated for deportation, but her paperwork has been lost. No one, on either side, whether our State or the state of ██████████, has complained. She lies in an in-between space right now, making her circle drawings. Now that this routine has been established, it's as though no time has passed since she was incarcerated.

Commander: But something must be done. The prison is closing. She can't just wallow.

Warden: I think ███████████ should be allowed a new immigration attorney, and this attorney should be presented with her artwork. A case could be made for cultural patriation.

Commander: And if she doesn't win in court?

Warden: Then she'll be deported back to ██████████.

Commander: The State's relationship to ████████ is tenuous as best. The Supreme Leader would be irked by another diplomatic incident. (*into intercom*) Could you send someone from the immigration court for this file, number ██████████, for Prisoner #29?

Warden: I'd like her work to go with her. Then it would be known that she became a great artist during her time here in detention.

Commander: Let's break for lunch.

Lunch

The Commander watches as the guards lead the Warden out of the deposition room. After the doors close behind them, he sighs and slumps back in his chair. In all his years of administrative and judicial work, he's never had to untangle such a political, social and cultural mess as this. He is grateful to the State and the Supreme Leader for their faith in him, but admits to himself that the hearings are taking a toll. This will be his last major case before his own retirement.

What does he imagine doing? Certainly, he'll look at art in the State Museum with a more rigorous eye. And the fact that his wife reads so many books by ███████ and has saved them for his downtime.... He'll have to make some excuse to get out of reading them, but he won't be able to tell her the truth. The world is complicated.

He stands up to walk to his chambers. There in the refrigerator is the sandwich he packed for himself earlier in the morning. He sits in his chair, overlooking the parking lot. His thoughts wander. He looks at the framed pictures of his two children. Max, graduating from the Air Force Academy. Diana, with her two children. What a world they all live in.

REPUBLICA

YOU R going NOWHERE

Prisoner #29: ███████████, **the Passport Artist; and**
Prisoner #30: ████████, **the Newspaper Artist**

Warden: ███████████ and █████ are identical twins. We've had them marked with unique tattoos by the Tattoo Artist but, just looking at them, they are impossible to tell apart. They were convicted of forgery. Forgery of money.

Commander (*reading*): The amounts are impressive.

Warden: Their strengths are in working together. ████████████ is good at faking images, photographs in particular. ██████████ is good at text, creating and laying out letters, making precise copies of fonts that no longer exist. Together, they're brilliant.

Their punishment has been twofold. The State has used their talents to make foreign passports for extraordinary circumstances. That is ██████████'s job; he's the brother with the talent for faces. █████████ has been entrusted with the State Newspaper archive. As you know, the previous state during the last epoch digitized all of its newspapers. Now, in the post-digital age, those technologies are obsolete, and we are having trouble retrieving the archive. The State paper, which you know is printed every day, has asked the brothers to re-create all the copies of the newspapers using the digital files, which were badly damaged in the Internet Wars. In this capacity, █████████ lays out the papers and fills in the missing or damaged portions. He has his brother, ████████████, fill in the missing pictures.

Commander: Is their work accurate?

Warden: It depends in what way you mean. Visually and syntactically accurate? Absolutely, yes. Historically accurate? We'll never know. And the historians of the future will never know.... But will it make a difference?

Commander: Where does the work take place? At the prison?

Warden: No, we don't have the room for it here. Both passports and newspaper restoration require special printers and equipment. Every day the ████████ brothers are taken in a van down to the State Archive building. They love their work. For that reason, we're getting them an apartment

downtown, from which they can simply walk to the archive. We want to make it as easy for them as possible.

Commander: Any chance of recidivism?

Warden: No. What we've learned about them is that they prefer power to money. And in writing and rewriting history, they have all the power they've ever dreamed of having, and more.

Commander: Doesn't the State find it problematic ...? (*holds up newspaper clipping*) This clipping reads, " ██████████████████████ ██████████████████ ."

Warden: Yes, they were censured for that. Now the physical newspaper is read by a panel of historians before being introduced into the archive. But in cases where fragments have to be manufactured, who is to tell if there were three people in the car that exploded, or four? If there is no material evidence to the contrary. Even the historians consulted have agreed—see the letter from the History Department chair at the State University—that historical work is often a forgery until someone else disproves it.

Commander: Two less inmates to worry about. Thank you.

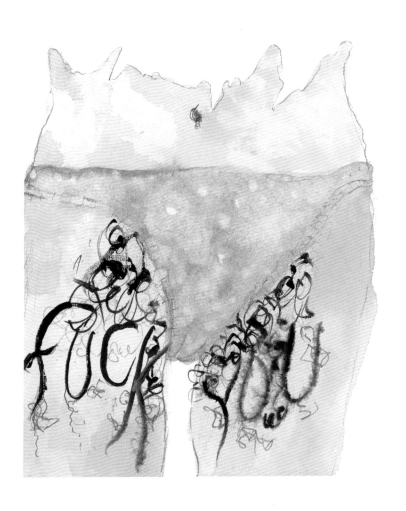

Prisoner #31: ███████████, **the Hair Artist**

Warden: In the last state there existed a time called the Victorian era, named for Queen Victoria, who ruled over what was known as the United Kingdom. Victoria herself was perpetually in mourning, and fashion during her reign tended toward the macabre. People seem to have enjoyed a reminder that death was just around the next corner. Hair was used in many cases, the hair of a dead loved one, to make intricate images. This was before photography, you see.

So, that's what Prisoner #31, the Hair Artist, does. She collects hair and makes pictures with it. We can't stop her. She gets it from the drain in her cell and the shower drain in the women's bathroom. We've had reports that she's snuck into the men's room, too, but we've never caught her. She comes to the art workshop with her material in her pockets. At first we made her throw it away, but she wouldn't stop. After the discovery that at another historical time hair art was ... normal, we adjusted our way of looking at her work. ███████████ now has a dedicated space in the art workshop. It's not large. Her pieces are minute. She works with tweezers and a magnifying glass.

Commander: But what are the images of?

Warden: Portraits. People send in photographs. Somehow the word got out. "To ███████████, care of the Artists' Prison." It sometimes takes her up to three weeks to finish a small portrait. (*gestures*) About this big. She doesn't charge a cent. The cost of materials, other than hair, that is, and paper ... the postage and envelopes, all comes out of her account here at the prison. She keeps that filled by doing small menial jobs—like cleaning the bathrooms, where she harvests her materials—and deposits from her family.

Commander: There's a complaint here in the file, from another prisoner.

Warden: Ah, yes, from the Magician. He's threatened because he thinks she's also working with spells. That's how magicians are, it turns out. You can't have two in such a small population, or else they get territorial. Except that ███████████ is not a magician. She doesn't believe that her work has any power of that nature. As a result of the Magician's complaints, we do have a special cabinet for her materials. (*off Commander's look*)

███████ separates the hair into different kinds: hair from the head, forearm hair, leg hair, pubic hair, eyelashes. And further by color. This sorting takes a long time, and per her request we've allowed ████████ to have her own dedicated and safe storage space in the workshop.

███████'s family has asked for her release, which has been granted. They're the ones who had her incarcerated. The charges they held against her have all been recanted. A waste of the State's time, I think. A family drama played out in the courts and prisons. But it will soon be over, and ███████ will be able to conduct her business from the safety of her own home.... Would it be possible to take a break?

Commander: Yes, of course. (*to intercom*) Guards?

Bathroom Break

After watching the guards escort the Warden out of the deposition room, the Commander pushes back from his chair and stands up. Down the stairs and discretely behind the raised desk is the door to the back hallway and his chambers. He walks to the water fountain and drinks twice from a conical white paper cup.

In the bathroom off his office, he runs a black plastic comb through his hair. He thinks again about his retirement, and can't help seeing it as his own release from a different kind of prison, the prison of his work. He begins to think about his hobbies, the golf clubs in the garage and the book he hopes to write from notes in his study. To stop these thoughts he steps into his office and stretches his arms above his head, before returning to the hallway and the deposition room.

Prisoner #32: ████████████, **the Scratcher**

Warden: We call ████████████ the Scratcher because she draws ornate images on her own skin, whether with her fingernails or a pin or pencil or fork. She seems to memorize images from art books in our library, then scratches them into her legs, forearms, stomach. (*holds up photograph*) Here's a bird known as a stork on the top of her left foot. She's figured out the right amount of pressure so as to never break the skin. There is swelling and irritation; the lines of the drawings are red, raised bumps, but never scab over. Each image lasts for two or three days. We don't bother to take her to the medical department anymore. There's no treatment. She's dedicated, disciplined and decidedly good at what she's chosen to do.

Commander (*holds up paper*): What is this form here?

Warden: Since her internment, ████████████ has put in a request for a photographic camera to begin the documentation of her work. Every six months we counter with the fact that she can use the camera we have on loan to the prisoners, that she doesn't need her own.

Commander: Where are the images?

Warden: We keep them in the safe in my office.

Commander: So what are the plans for Prisoner #32?

Warden: She's on the short list for the faculty position in sculpture at the State Academy of Fine Arts. It's my sense she'll get the job, and then it's simply a matter of the transfer paperwork.

Commander: A successful case.

Warden: Yes. It has been wonderful to watch the transformation.

Commander: She was interned with you for ...?

Warden: Attempting to scale the State's largest building. A stunt. Then resisting arrest. But we saw big potential in her, and through the influence

of the other prisoners, she was able to carve out a niche for herself.
So to speak.

Commander: Note taken. If only every case were so straightforward.

Prisoner #33: ███████████████, **the Fire Artist**

Warden: Committed to us for five years on arson charges, there's no doubt that ██████████████ is a pyromaniac. You can see it in his eyes; he's looking at everything, every day, for its potential as kindling. He mostly torches toilet paper now. Everything is flame proof in his cell, except for the toilet paper. We've learned that if we let him go too long without burning something, his condition worsens. So we let him encounter fire on a regular but random basis. A lighter dropped by a guard, a magnifying glass left out "accidentally" by the Hair Artist, matches near the kitchen ... all to be found by ██████████████. It is no surprise that the Coincidence Artist is ██████████████'s best friend. They spend every day together, analyzing and enumerating the coincidences of incendiary devices, the patterns, the signs.

In the library one of the staff researchers encountered a movement in the last state called "surrealism." Paul Eluard was a surrealist. One of the strategies for drawing they used was called "fumage." They drew with smoke. We've been encouraging ██████████████ into the workshop, to try it. Surely, yes, the images, like gray clouds across the pages, are beautiful. But what's more intriguing is watching ██████████████ learn not to burn something all the way through. To appreciate the ambiguity of smoke. His experiments and drawings are part of the prison's collection, which will, as you know, be transferred to the archive of the State Museum.

Commander: And ██████████████?

Warden: I've asked that he remain imprisoned. Thirty-five people died in the temple fire he set. And he's never shown remorse. In his transfer documents I've recommended that he be allowed to continue his artistic practice.

Prisoner #34: ████████████, the Pinhole Camera Artist

Warden: My bias will show in discussing ███████████'s work. I have strongly supported his endeavors, out of my own curiosity. And I confess, out of my discretionary funding. His proposal intrigued me. To turn his cell into a pinhole camera. What this required was blacking out the window, inserting chemically sensitive paper into the cell's back wall, and reducing the observation peephole to a point where light could enter.

After discussing the proposal with ██████████, we both realized the cell couldn't have any furniture in it. When ████████████, a former prisoner died, his cell, which was too small for State regulations, became available. I proposed that we turn it into a camera instead.

After many months of experimentation, with the right paper size, exposure time and lighting in the hallway ...

Commander: At a cost to you personally of ██████?

Warden: Yes, but as I said, from my discretionary fund, with ██████████ funding the balance. What has emerged are beautiful, large-scale photographs of guards and prisoners walking down the hall, in a shimmering blur. Those in the know sometimes stare directly at the door, or pose for as long as they can get away with it, not knowing whether the camera is working.

We showed the first prints to the Rubber Stamp, who without rolling his die stamped the back with his ████ stamp, no hesitation. He wrote a letter to the State Museum about ██████████'s work, and because he hadn't been in contact in so many years, the museum took this as a clear sign. ██████████ was offered a solo show; it opens next month. As part of the agreement, the sales of the work will be handled by ██████████ Gallery, and the first cost to be reimbursed will be production, to my discretionary fund.

Commander: A gamble that paid off.

Warden: Yes, sir. I don't say this very often, as it is a personal opinion, but this artwork is truly innovative. It has been a pleasure to be part of the process.

Commander: I see. But what of his crime? (*reads*) Classified document, State Department of Science and Technology. Not even I am allowed to read it.

Warden: And ▮▮▮▮▮▮▮▮▮ has never confessed it to me. My sense is that those who committed him here have a plan for what to do with a man of ▮▮▮▮▮▮▮▮'s knowledge.

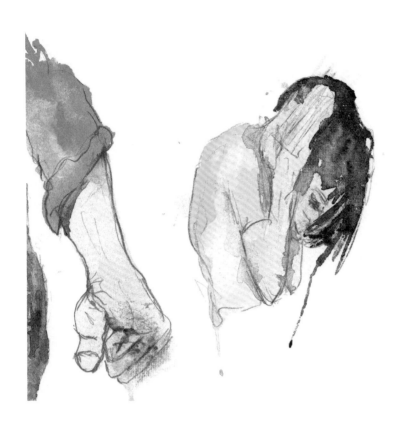

Prisoner #35: ███████████, **the Title Artist**

Warden: ███████████ makes up titles for artworks. Simple as that. Or so it seemed to me until I witnessed firsthand how hard this task is for our other inmates. At first ███████████ just sat in the workshop, offering his advice free of charge. He wouldn't even bother looking at the work, yet he would come up with the most fitting title for it. I've come to see that in the world of art there are eye people and ear people. Eye people look at the work. They find the value of it through looking. They don't need other people's judgment to know what they think. Then there are ear people. Ear people don't know what their eyes see. They need other people, to hear other people, to form their opinions about what they look at. That's where ███████████ comes in. His skill caters to the ear people. Once you hear his titles you can't wait to see what he is describing. The Rubber Stamp won't have anything to do with him, because even with his die he's ultimately an eye person. But it doesn't bother ███████████; he keeps his titles listed in a little notebook in his uniform's breast pocket, and once a month he comes into my office and dictates it to me.

Commander: What happens to the list then?

Warden: We post it outside the prison. To the left of the front door. There's a case and a bulletin board. The press and some art students come and look at it. The distribution is somewhat erratic, but sure enough, in the art journals and newspapers over the next six months to a year, there is a real effect. ███████████'s titles crop up everywhere. He has found a way to have real influence.

Commander (*reads*): *Rotation 12, Heliotrope. Untitled (Radical Helix 4).* (*looks up*) How influential can this be?

Warden: Surprising, isn't it? The Rubber Stamp and the Title Artist vie for the most influence, I'm sure. Except that ███████████ won't look at art. He doesn't believe in looking.

Commander: What happens to him? He was only supposed to be held here overnight.

Warden: As happens sometimes. Disorderly conduct after a night of drinking can be the gateway to a longer stay here than expected.

Commander: But his behavior has been exemplary. What was the pretext, either his or yours, for his stay? (*reading*) Seven years? That's extraordinary.

Warden: I think he was enjoying himself. I never asked him to leave. And the fact is that he comes from a good family—his expenses are paid every month. My guess is that he'll leave when the prison doors close. No one knows his identity besides me, and now you. He'll never encounter his prison-mates again; they have such certain endings. I've driven by his house, you've probably seen it, on ███████████ Square near ███████ Street. I assume he'll just move home.

Commander: And the titles?

Warden: I have no doubt, given his position, that he'll find a way to disseminate them. I look forward with great interest to learning how he does it.

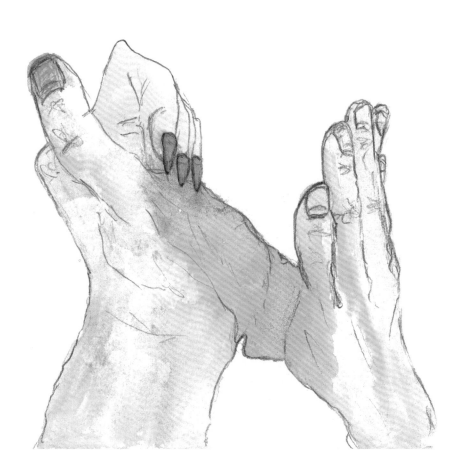

Prisoner #36: ███████████, **the Clapping Artist**

Warden: Prisoner #36 claps. Some days I'll be walking down the hallway, and I can hear it, steady, rhythmic, coming from her cell. Sometimes she'll start clapping in the dining room, and the other prisoners will ignore her. I can hear ███████████'s deep baritone say, "Shut up, ███████████," and she will. Sometimes, at a musical performance or a birthday, ███████████ will clap and keep everyone clapping too. Clapping, in a good moment, can be like laughing—it catches. That's why we call her the Clapping Artist.

Commander: Is there any role for her outside the prison?

Warden: No, not really, but then neither is there inside. Her prison term is up next year, and I vote that with good-behavior credits she be paroled early, at the time the prison closes.

Commander: Any fear of recidivism?

Warden: She threw acid in the face of her rival. She has apologized and served her time. There's nothing more the State can do in this case.

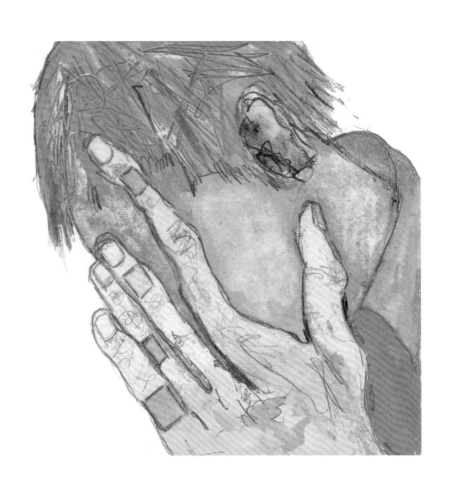

Prisoner #37: ▮▮▮▮▮▮▮▮▮▮▮▮▮, **the Failed Artist**

Warden: ▮▮▮▮▮▮▮▮▮▮ sits all day in a stasis of failure, her thinking fraught with negativity. You can palpably sense her thoughts ... heavy, loaded, negative. If she looks up and out of herself, she is happy to discuss her epic failures, a staggering number, according to her.

Commander (*leafing through file*): But her resume is here, and she has barely accomplished anything. The list ...

Warden (*leafing through her own file*): She did graduate from the State Academy of Fine Arts ...

Commander: No other inmates have done both the academy and the prison?

Warden: No, in that accomplishment she is unique.

Commander: And quite costly to the State, I would add. We're not a welfare platform.

Warden: She has had no exhibitions, published no books. Every project she starts she is unable to finish. The amount of time she spends complaining is at least seven to eight times the amount she puts toward anything. Personally, sir, I believe that an initial complaint can be a form of brainstorming or problem solving. But infinite complaints just lead to a state of failure. I confess that I avoid her at all costs. But I'm part of the problem. By reacting I contribute to her work, toward building herself up as the Failed Artist. Each person who listens, or even avoids her, adds to her construction. Her goal, I think, little by litte, is to build her cult of personality and be the most successful Failed Artist, a black hole of negativity. In essence, her "artwork" is a perpetual performance investigating abject failure.

Commander: What was her crime?

Warden: That was her crime! Being a psychic vampire to everyone she comes into contact with. We've been trying to find an adequate punishment and haven't succeeded. She's toxic, seemingly innocuous, and utterly unstoppable. I've been consulting a book in the library, *The Prince*, by

Niccolò Machiavelli. In the eighth chapter he writes about princes who become heads of kingdoms through nefarious means. This has held my attention. What is particularly difficult about ███████████ is how we all understand power in relation to her. She erodes it, gathers it to herself, but why? For what means?

I've never made this recommendation before, even though I have the power to do so. I recommend that she be put to death. There is no good that can come from her.

Commander: I'll take your comments into consideration.

Warden: The Echo Chamber, sir. Two less problems for the State.

Commander: From an arithmetical standpoint, it does seem that simple, but there are laws and standards to consider. Though I've made a note of your suggestion. Anonymously, of course.

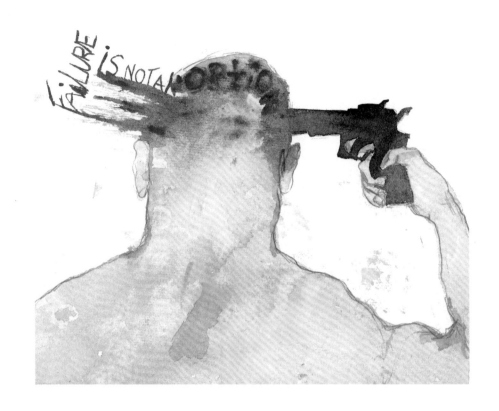

Prisoner #38: ████████████, **the Artist Who Couldn't Fail**

Warden: ██████████ was a highly regarded artist both here and abroad. You'll see his exhibition list is very long.

Commander: And he is represented by ██████████ Gallery. You say "was"?

Warden: I'm afraid so. It's a sad story. ██████████'s work has set auction records. Every work he made sold. Every move he made was successful. His museum shows have lines around the block, people waiting to see his installations, his paintings, the videos of his performances. His work is all about shame, about male confusion, about his own sense of failure. But the more he exlpored these themes in his work, the more successful he became. He hated the art world, he hated the art market. He came here, to the Artists' Prison, to hide from it all, only to find that the Rubber Stamp was stamping his work with gold.

Commander: But I thought that no one who knew the Rubber Stamp was at the prison?

Warden: I never confirmed it with ██████████, but he knew. He was always right. He couldn't escape his constant success. Everything that he touched, his own sadness and sense of worthlessness, everything was success. He couldn't fail.

██████████ committed suicide last week. We are all deeply saddened, as his presence, his self-deprecation, small talk and fury at his own success made for witty conversation. We didn't see it coming. Even at suicide he was successful.

Commander: What do you mean?

Warden: When we found him, his body appeared majestic and perfectly poised. Reminiscent of a famous painting in the State Museum called *The Death of Marat*.

Commander: How did he die? The medical record isn't in the file.

Warden: No, the autopsy is still under way. I'm pretty sure it was poison, but the official report will confirm or deny it.

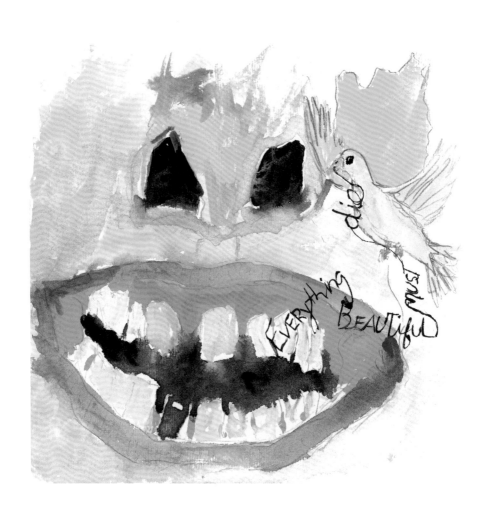

Prisoner #39: ████████████ **, the Artist Who Thinks He's a Bird**

Warden: Every year ████████████ is given one feather pillow. That serves as his materials. We normally don't allow the prisoners to embellish their uniforms, but in this case we've made an exception. White feathers, white uniforms.

Commander: Exceptions seem to be the rule at the Artists' Prison!

Warden: Yes, sir, I agree. To a degree. In every other way, ████████████ is just an average prisoner. Gets up, follows a routine of eating and studying the Koran in the library every afternoon. He only uses the workshop when he covers, sewing by hand, his uniform with white feathers. Nothing else is covered by feathers, just his clothes. And as the feathers wear off, he sews more on, until the next year's uniforms are issued. Oh, and yes, one behavioral trait. Though it is clear that ████████████ can both read and write, when addressed directly, he only answers back in a bird call or a chirp. Or even a cockle-doodle-doo.

We thought it would wear off, but for three years this has been his behavior.

His crime was corruption, skimming the top off State coffers. ████████████'s a rigorous accountant, or was. Until he enriched himself. And then gambled it away at the ████████████ casino in ████████████. The staggering losses and the fact that he could cover them were what alerted the Fraud Department.

Commander: Why was he sent here, to you?

Warden: It's not commonly known, but he's the first cousin of the Supreme Leader. It was thought that here, under my authority, he would be easier to manage and less likely to embarrass the State.

Commander: And the feathers?

Warden: The medical department has cross-referenced other cases, with no matching psychological profile. Is he playing a chicken? Too easy. It began the first night—he ripped open his pillow and brought the feathers to the workshop the next day. Every year he requests a new pillow—as I said,

he can write perfectly well.

What will happen to him? I don't know. I do know it is not up to me ...
and thinking about it, probably not you, either. If he is released, he's
unemployable unless the State runs the Redemption Package on
him ... media, marriage, et cetera. He could be an ambassador. If he stays
in prison, it'll be a lifetime of sewing feathers, if the next so-called coop
is as lenient as this one has been.

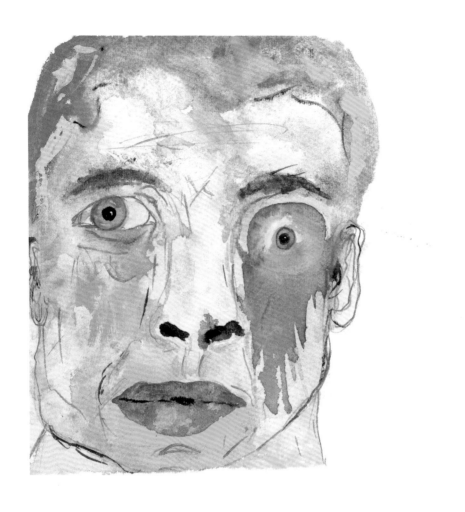

Prisoner #40: ██████████████ **, the Evil Eye Artist**

Warden: ████████████ makes charms. Some out of blue glass, some out of diamonds and sapphires. Evil eyes, he calls them. To hang on the wall, or on the rearview mirror. Even around the neck. (*takes out her own necklace, shows the Commander, and tucks it away*)

Commander: You know as well as I do those aren't allowed. Why are you showing me?

Warden: Because of my immunity. ██████████████ was incarcerated because he was a propagandist of belief. Sure, the Coincidence Artist is tolerated—signs, synchronicities—all that can be written off as superstition. But evil eyes? No, those are symbols whose role directly overlaps with the role of the State. The State wants to be the only symbol, the only all-seeing eye. As we both know, the State's symbol is an eye. The Evil Eye Artist isn't making the State's symbol, he's making something old and pagan, something that's been human as long as there have been humans, a talisman to protect the good from evil. And I have a sense that the evil eye will be here longer than any state.

Commander: Your words are protected, but they are verging on sedition, something I will have to take into consideration. And you allow him to keep making evil eyes, here in this prison, under your watch?

Warden: I can't stop him. When I've tried, he outsmarts me. A small square pendant and then I think, "He's moved on." But that's when I see it, the dot in the center, like a pupil.

Commander: Why don't you take away his materials? Like the Water Artist.

Warden: I tried. But like the other prisoners, ██████████████ is ingenious and convincing. He'll trade for materials, stick a piece of wire up his urethra, a small stone up his nostril, where we would never search. And then, he'll give them away. It was the guards first. I accepted mine without knowing what it was. I thanked him, and then I realized that the necklace protected me. That's when I saw that he had won. Because the necklaces work. (*off Commander's look*) It's heretical, I know. But whether we stockpile them or burn them, they get out, these evil eyes. They have a life of their own. You

keep him in prison, you let him go, the result will be the same. That is my recommendation. ███████████ is in prison for a crime he is still committing. His output and the market demand are unabated. The State is "damned if you do, damned if you don't." Unless, of course, ████████████

████████████████████████████████████.

Commander: I will have that portion of your deposition redacted, for your own safety.

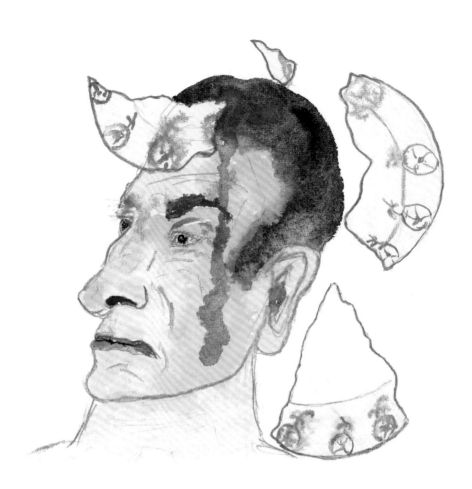

Prisoner #41: ███████████, **the Broken Plate Artist**

Warden: Last year, after accumulating an enormous quantity of broken plates and bowls, we tried a treatment program with several inmates in the prison's garden. Four inmates were selected—████████████, ████████████, ████████ and ████████████—because they weren't suicidal, and that was the main concern with the sharp edges of the broken plates. The idea was to train them to use the pieces to cover the benches and low-lying walls of the vegetable garden with mosaics. One by one, they discovered they didn't want to do it. ████████████ was allergic to pollen, ████████████ didn't like being outside in the sun, and ████████ claimed to be scared of bees, worms, spiders, what have you. So only ████████████ remained. By himself, to our amazement, he covered the walls and benches, fitting the shards together like puzzle pieces. Other prison officials, having heard of his work, have submitted requests to have ████████████ come and work at their prisons. As you can see, we have many requests that ████████████ be transferred. The demand far outweighs his output.

Commander: Well, what does ████████████ want to do?

Warden: Like you, I believe it is up to him. With your permission, I will show him the requests and see which one he prefers. He, like the Panorama Artist, is in prison for life. Despite his crime, I consider him a success. He came to prison with no aptitude for art, and now it is his calling. He is not treated or treatable, but within this narrow scope has a way to function within the State.

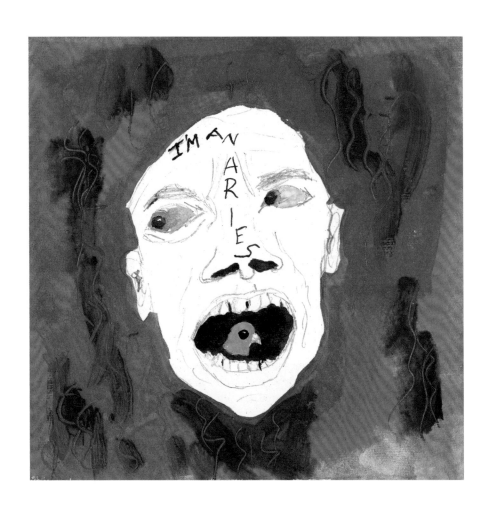

Prisoner #42: ██████████████, **the Astrology Artist**

Warden (*reading*): Stubborn, insistent, headstrong, impatient, born new to the earth, curious, in love with beginnings, creative.... These are a few traits of Aries, an astrological sign associated with the constellation formerly known by the same name. Now we can no longer see the sky at night, except in regions of the interior forest or ocean. We live now in an age of light. In earlier eras, astrology was a study different from astronomy, and astronomers looked down on it. But in our State they are once more linked. We can't see the planets or stars, so we sense them and their effects. Our birthdate is also our sign. Since death is now either chosen or assigned, we are obsessed by the accident of when we were born.

██████████████ is preoccupied, in the same way other artists are, with traits that make artists artists. I have been the Warden here for thirty-four years and know from my experience that no one thing makes an artist an artist. It is a grouping of traits and timing.... You can't only want to be an artist. I've seen prisoners who want to be artists fail, and some criminals, who arrived here with no idea that they were artists, succeed.

██████████████ believes that people born, like him, under the constellation of Aries make the best artists. He believes in a pattern. (*holds up a document*) He has assembled a list of all the Aries artists in the last six hundred years.

Commander (*looking through his copy*): James Ensor, ██████████████ ██████████, Leonardo da Vinci, ██████████████, Al Green, Goya, Joan Miró, Raphael, Vincent van Gogh, ██████████████, ██████████████, ██████████████.... What a list. He may not be wrong about the Aries connection. (*reading to himself*) I see your name is here. One of the few women.

Warden: I couldn't disguise it. I know he recognized me, but I never let on.

Commander: This could be fatal for him. Has anyone else seen this list?

Warden: The one in your folder is the original. I have the single copy here. It has never been disseminated.

Commander: We must destroy it.

Warden: And ███████████?

Commander: How much do you trust him?

Warden: It would depend on whether or not he was working for me.

Commander: I see your point. I'll make a note of it. (*wearily*) But what's his crime?

Warden: Aries-centrism. The current Supreme Leader was born under the sign of Aquarius.

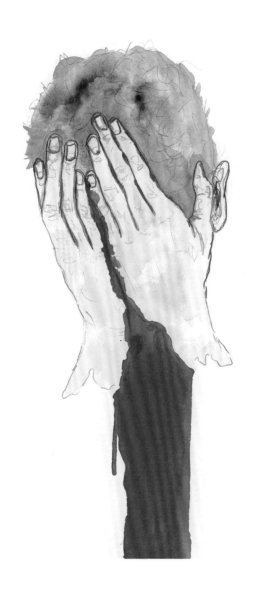

Prisoner #43: ███████████████, **the Warden**

Warden: One final prisoner. ██████████████, the Warden. Convicted in 19██ for ███. I don't have the file in front of me ...

Commander: There is only one. (*holds up the file*) The sentence, decided in this very building, was an unusual one, a particular punishment for a particular kind of criminal.

Warden: Yes.

Commander: I was the judge during that sentencing hearing.

Warden: Yes.

Commander: You've served thirty-four years today, for the crime of ██. Over half your sentence. To be Warden of the Artists' Prison, for forty-three years or until it closes. And now, the Artists' Prison will close. In a month. I have listened to all your recommendations for the other prisoners.

Warden: Yes, except for one.

Commander: Go on.

Warden: Prisoner #43, the Warden, has served thirty-four years of her forty-three-year sentence. The Coincidence Artist would have a field day with this fact. The Warden's behavior has been good. There is no chance of recidivism. She has observed artists and non-artists alike, and she is neither an artist nor not-an-artist. She has served her duty to the State in good faith thus far.... It is not up to me to make the judgment in this case, sir.

Commander: I understand your hesitancy. You have served your time diligently. It is my recommendation that you be released immediately to your new duties.

Warden: Thank you, sir.

Commander: (*into intercom*) Guards! (*to Warden*) Just remember, the freedom you have earned is a form of further service.... (*more humbly*) And congratulations.

Warden: Again, thank you, sir.

End of the Day

As the Warden walks down the corridor, the guards walking one in front of her and one behind her, she can sense the difference in their behavior already. They lead her away from the cafeteria and the deposition room. She begins to think they have walked into a different building. This one has carpeting.

They stop at a door, one guard flanking each side. She looks for a moment, and then sees her name in gold lettering under her new title. As if on cue, the guards bow toward her in tandem.

The Warden reaches for the door handle and turns it, pushing the door in. Inside is a dressing room with a large mirror, a sofa and another door, ajar, which she guesses is the toilet. She steps inside and closes the door behind her.

Then she sees it. A clothing rack, with her new uniforms. The suits, in purple, with her name and the insignia of the State sewn in gold thread. "█████████, Supreme Leader."